First Words

Premiers Mots

Primeras Palabras

Erste Worte

Prime Parole

Ivan and Jane Clark Chermayeff

Harry N. Abrams, Inc.,
Publishers, New York

Close your eyes. Open them. What do you see? What is in your room? Describe your favorite things and favorite places. Could you make a picture of these places and things? Can you make a picture of a chair or a flower or a hat? Artists and artisans also see things in their own way. Sometimes they make images that are clear and precise; other times, images only give a feeling, leaving us to fill in the details.

Often, the details are only bits and pieces of the whole story—teeth and spots make dogs; cats are tails and whiskers; birds are feathers and wings; horses stand high on long, thin legs. Every animal has its own special way of being, and every artist makes those ways come to life differently.

Painters and sculptors through the centuries have told us—through color and line, clay or metal, and many other mediums—how the world, and everything in it, looks to them. Art is a window on a time and a place. When we look at art, we are given an extra pair of eyes. Art makes it possible for us to understand how we can see the same things differently.

First Words began as a game with our five-year-old son, Sam, during a sabbatical in Paris. Together we visited many museums, looking at paintings and objects and describing to each other what we saw and felt. From the five museums represented here—Musée du Louvre, Musée National d'Art Moderne, Musée d'Orsay, Musée National des Arts et Traditions Populaires, and Musée des Arts Décoratifs—we collected images of "first words" that Sam was learning to spell in English and repeat in French. We soon realized that, as we looked at different ways of *seeing* through art, we could also explore different ways of *saying* the same thing through other languages, and we added Spanish, German, and Italian translations.

Museums, when visited on short, focused trips, are learning places for the very young as well as for their parents. Looking at art is a way of learning to share as well as to see, and that is what this little book is all about. I.C. & J.C.C.

boy

le garçon

el niño

der Junge

il ragazzo

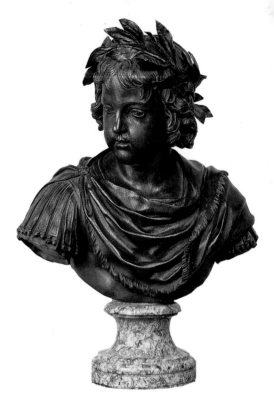

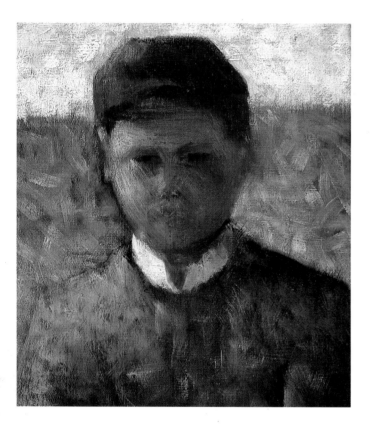

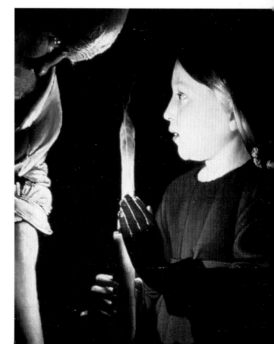

4

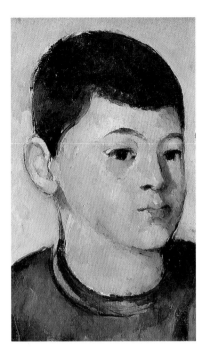

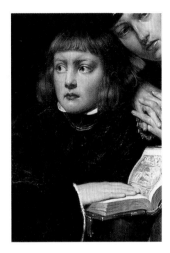

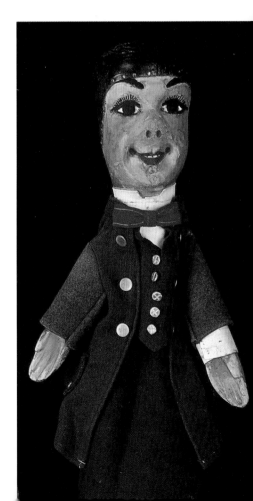

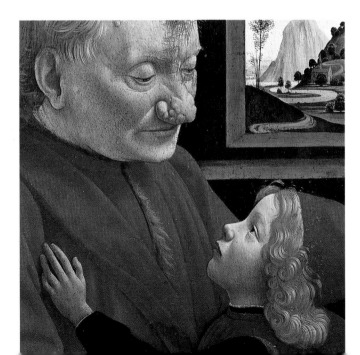

cat le chat el gato die Katze il gatto

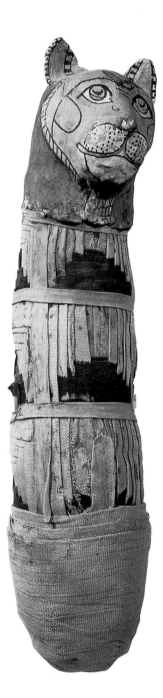

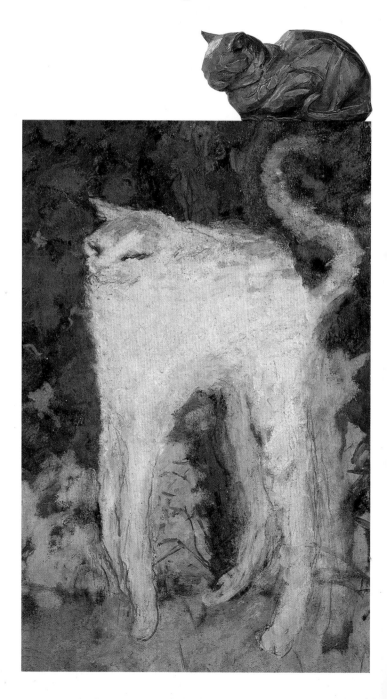

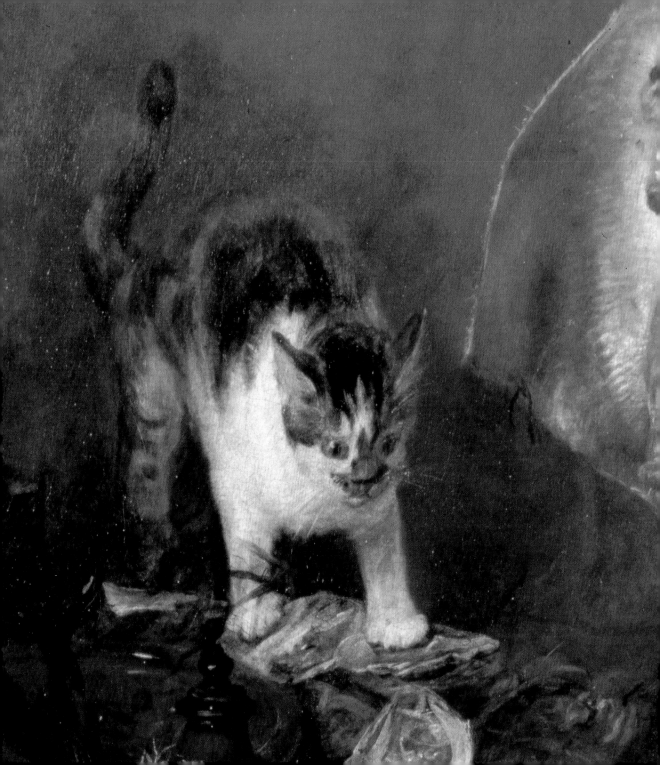

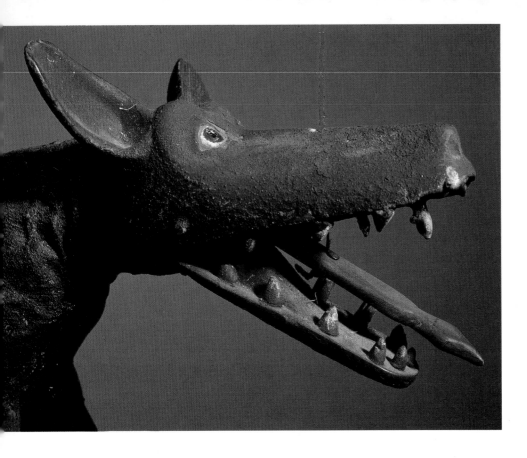

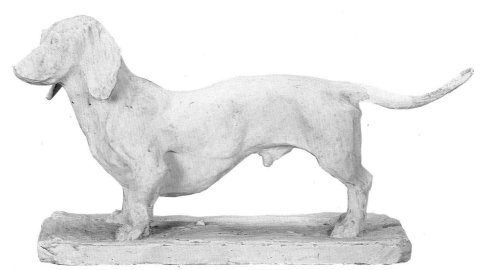

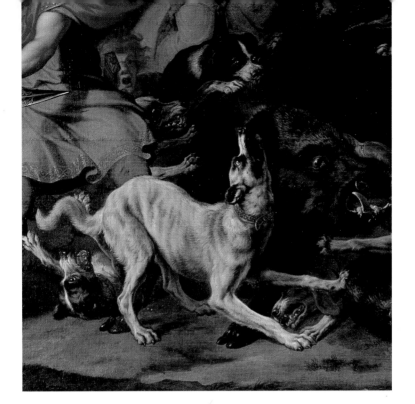

dog le chien **el perro** der Hund il cane

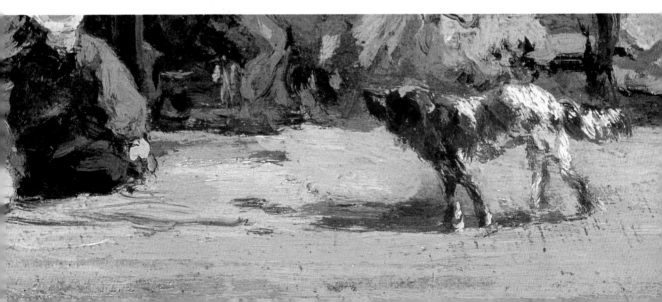

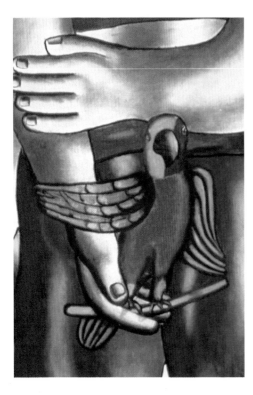

bird

l'oiseau

el pájaro

der Vogel

l'uccello

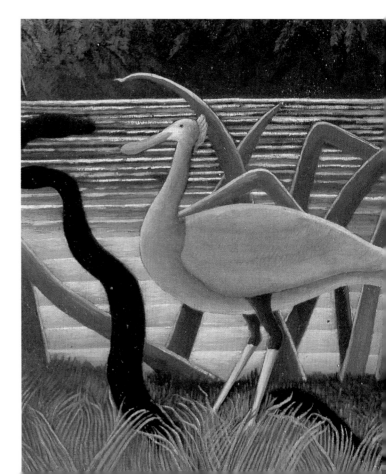

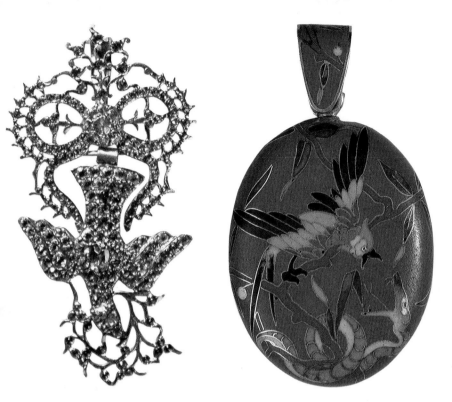

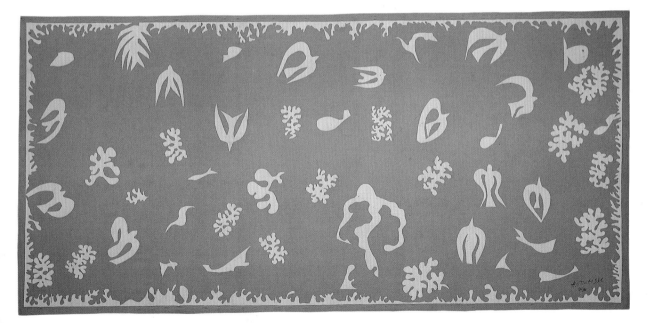

girl la fille la niña das Mädchen la ragazza

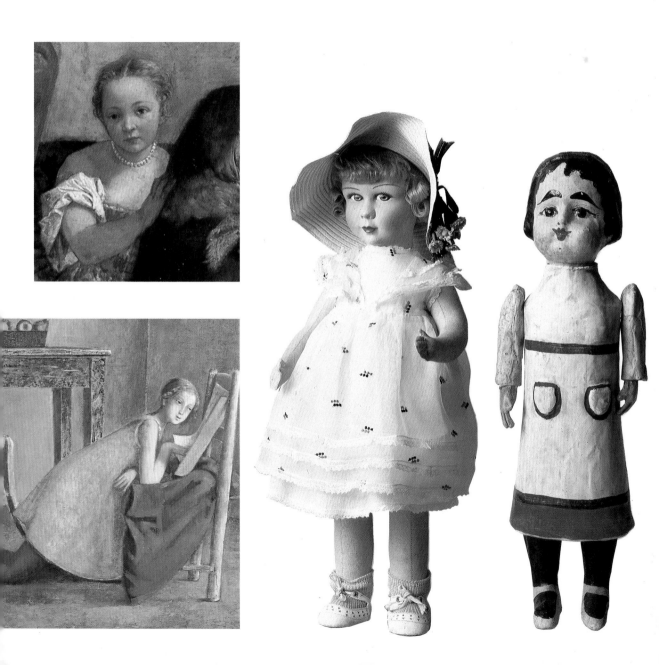

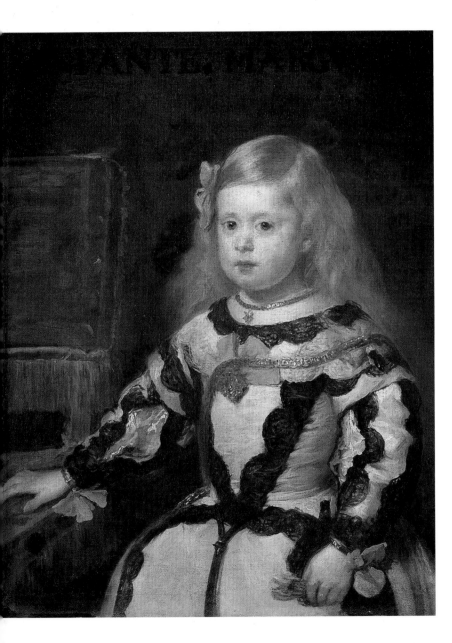

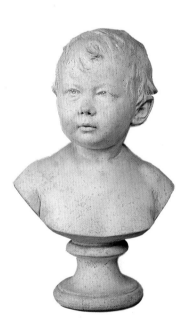

13

flower

la fleur

la flor

die Blume

il fiore

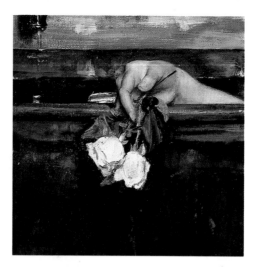

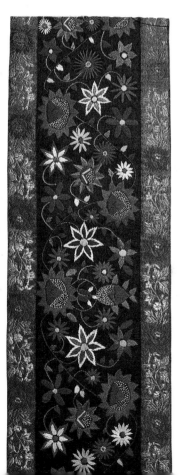

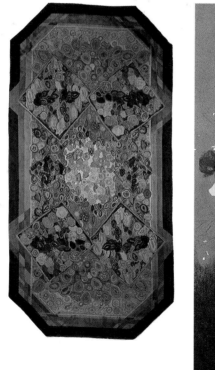

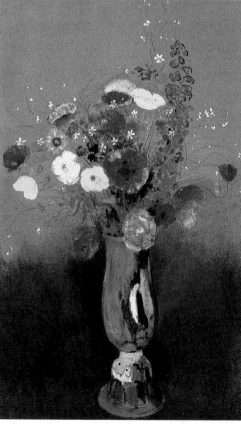

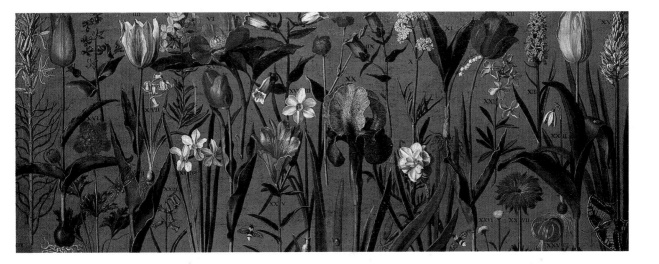

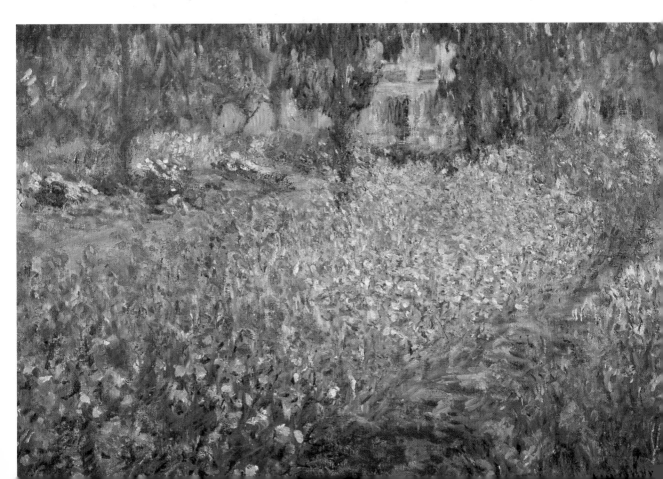

eyes les yeux los ojos die Augen gli occhi

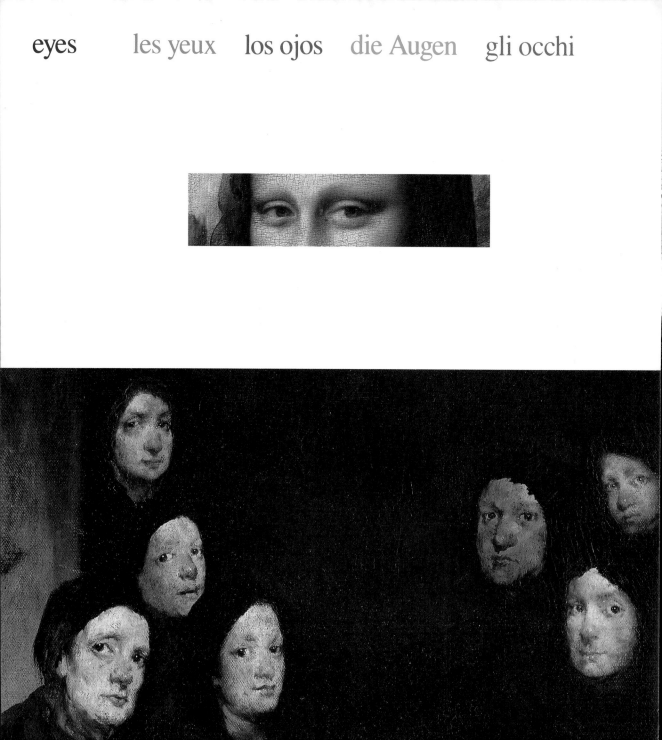

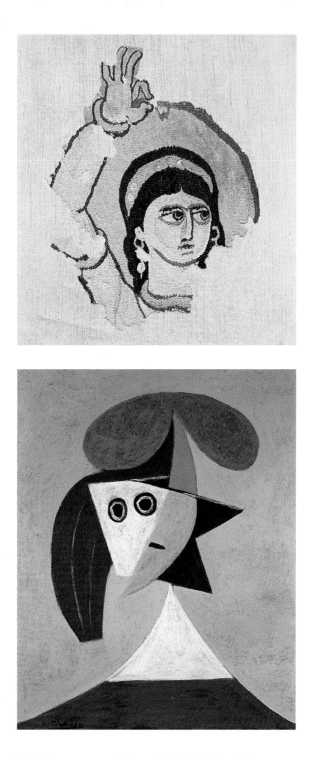

chair la chaise la silla der Stuhl la sedia

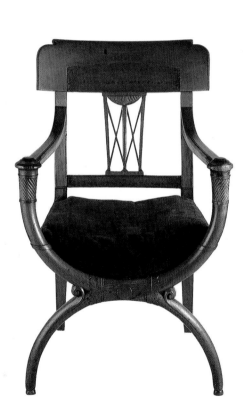

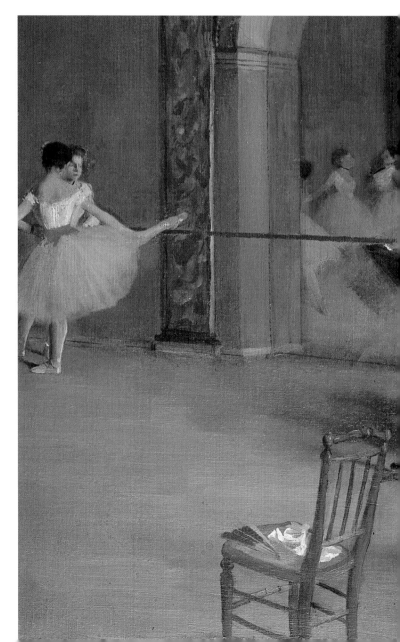

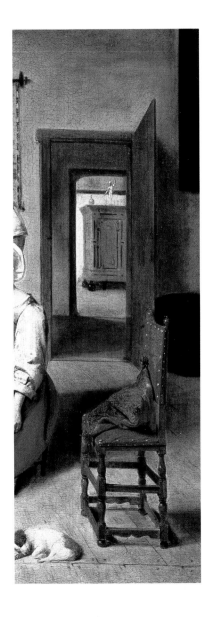

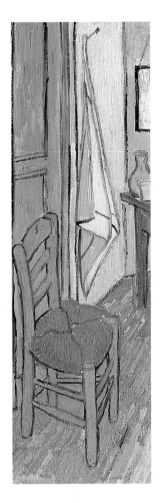

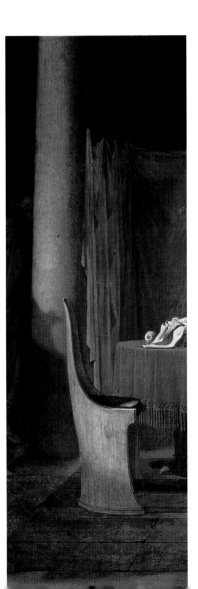

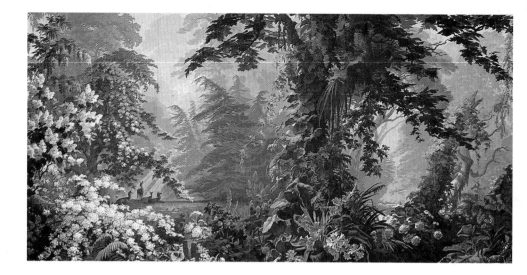

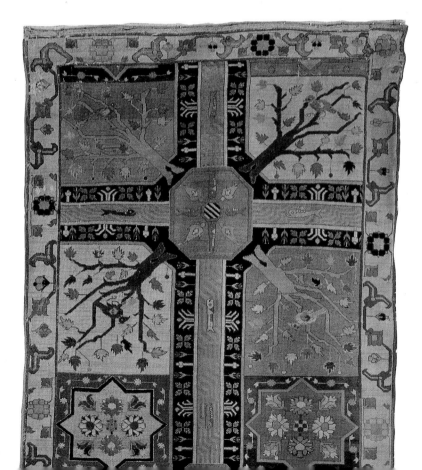

tree

l'arbre

el árbol

der Baum

l'albero

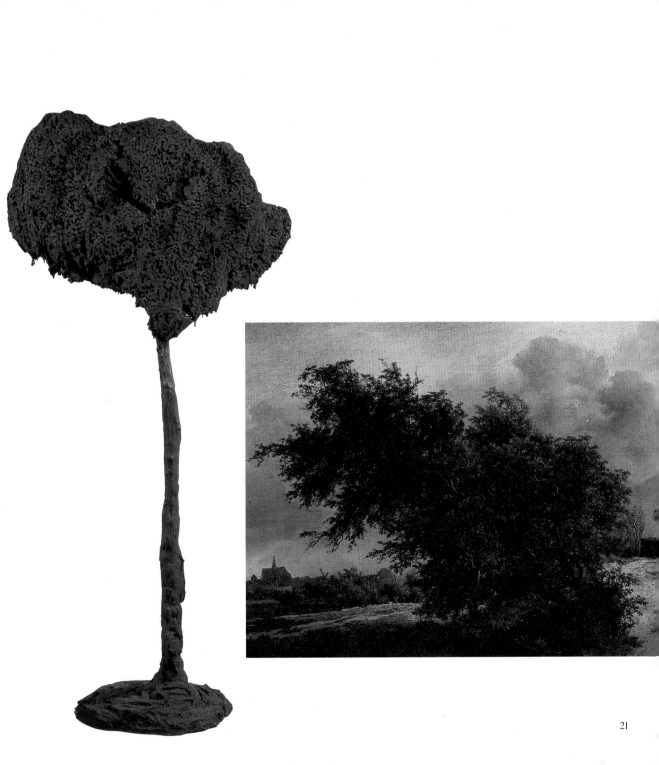

hat le chapeau el sombrero der Hut il cappello

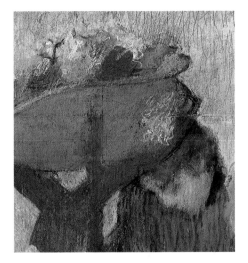

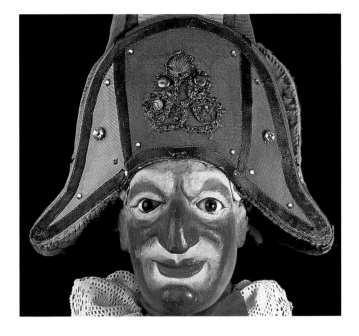

horse

le cheval

el caballo

das Pferd

il cavallo

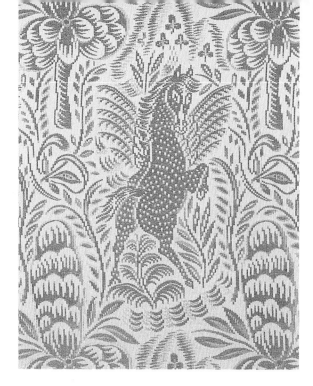

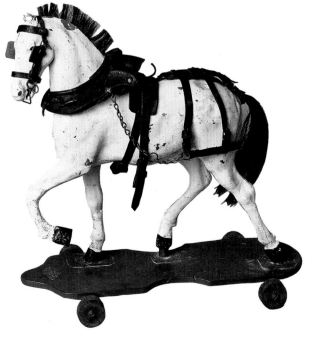

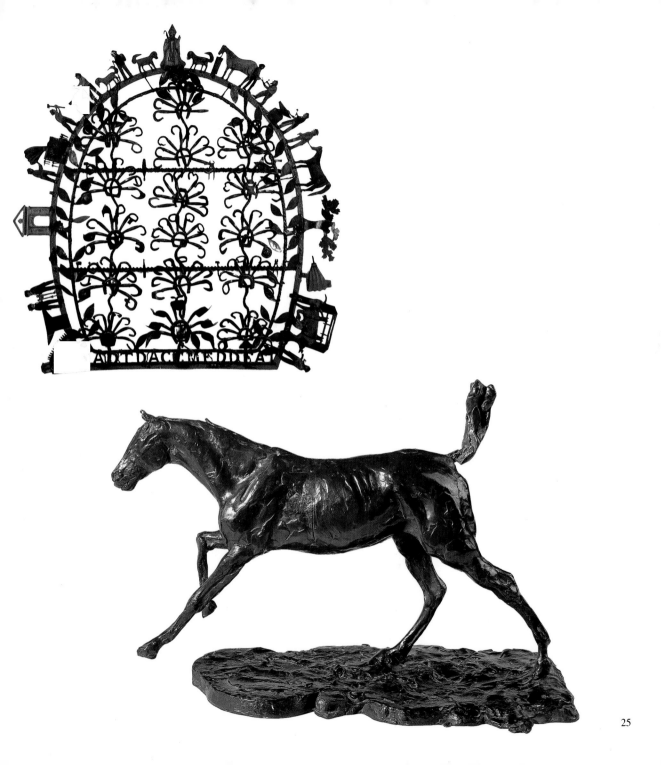

fish le poisson el pez der Fisch il pesce

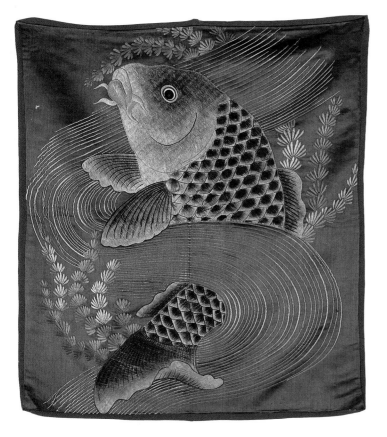

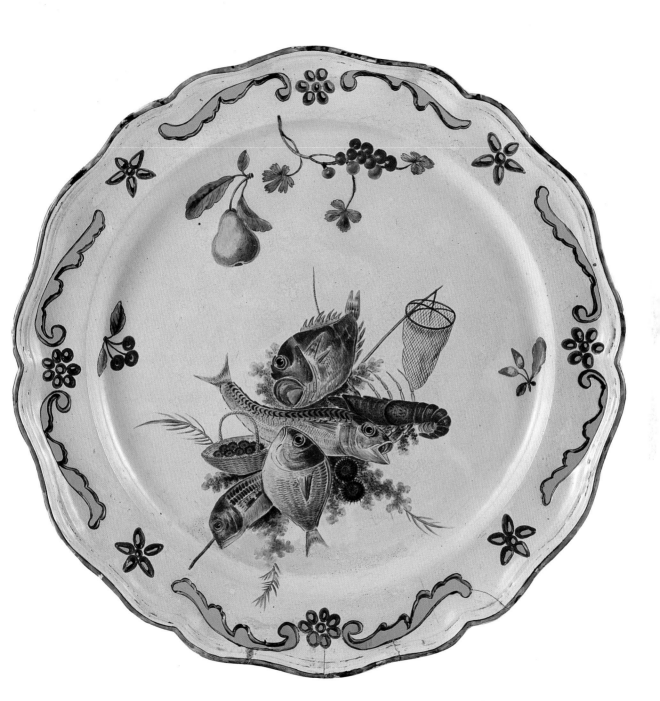

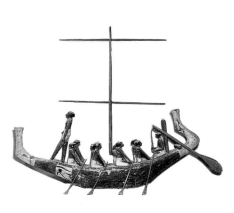

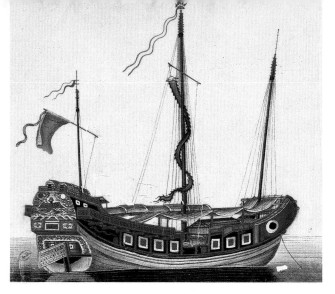

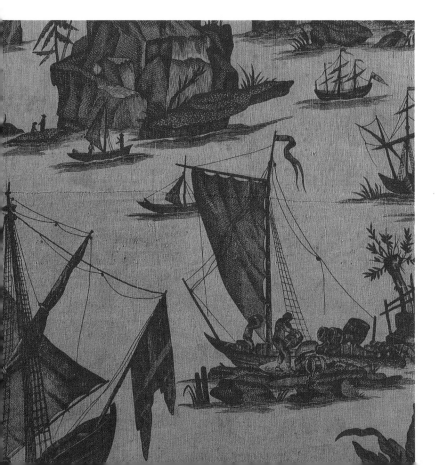

boat

le bateau

el barco

das Boot

la barca

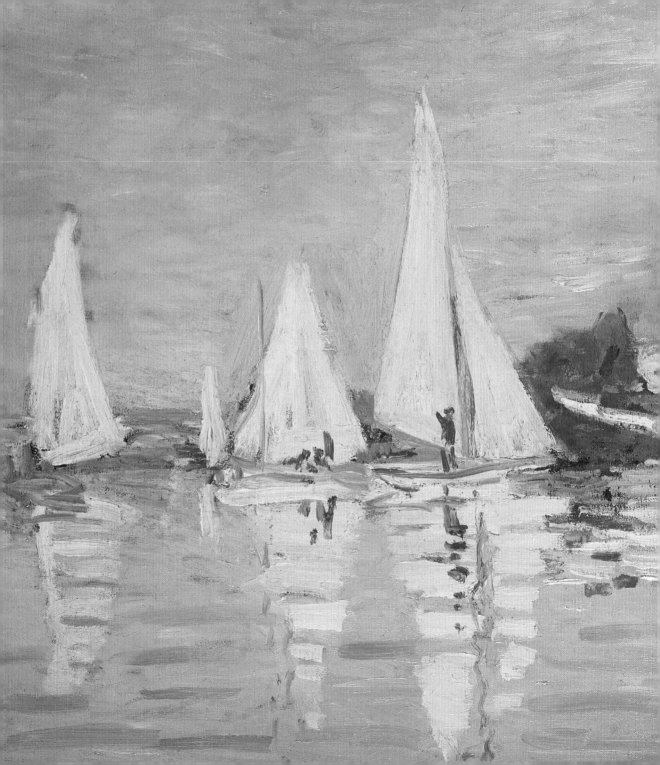

Pronunciation Guide

boy	le garçon	el niño	der Junge	il ragazzo
	lə gar-SÕ(N)	el NEE-nyoh	dehr YOON-gə	il ra-GA-tzoh
cat	le chat	el gato	die Katze	il gatto
	lə SHA	el GA-toh	dee KA-tzə	il GA-toh
dog	le chien	el perro	der Hund	il cane
	lə shee-Ã(N)	el PEH-rroh	dehr HOONT	il KA-nay
bird	l'oiseau	el pájaro	der Vogel	l'uccello
	lwah-ZOH	el PA-ha-roh	dehr FO-gəl	loo-CHEH-loh
girl	la fille	la niña	das Mädchen	la ragazza
	la FEE-yə	la NEE-nya	das MADE-chen	la ra-GA-tza
flower	la fleur	la flor	die Blume	il fiore
	la FLER	la FLOR	dee BLOOM-ə	il fee-OH-reh
eyes	les yeux	los ojos	die Augen	gli occhi
	lay ZYE(R)	los O-hos	dee OW-gən	yee O-kee
chair	la chaise	la silla	der Stuhl	la sedia
	la SHEZ	la SI-ya	dehr SHTOOL	la SEH-dee-a
tree	l'arbre	el árbol	der Baum	l'albero
	LAR-brə	el AR-bol	dehr BAOWM	LAL-beh-roh
hat	le chapeau	el sombrero	der Hut	il cappello
	lə sha-POH	el som-BREH-roh	dehr HOOT	il ka-PEH-loh
horse	le cheval	el caballo	das Pferd	il cavallo
	lə shə-VAL	el ka-BA-yoh	das PFEHRT	il ka-VA-loh
fish	le poisson	el pez	der Fisch	il pesce
	lə pwa-SÕ(N)	el PES	dehr FISH	il PEH-schay
boat	le bateau	el barco	das Boot	la barca
	lə ba-TOH	el BAR-koh	das BOAT	la BAR-ka

Boy *(counterclockwise from left):*

Georges Seurat. *Young Peasant in Blue (The Jockey).* 1882. Orsay
Georges de La Tour. *Joseph the Carpenter* (detail). c. 1645. Louvre
Domenico Ghirlandaio. *Portrait of an Old Man with a Young Boy*
(detail). c. 1480. Louvre
French (Lyons). Marionette, *Punch.* Early 20th c. ATP
Paul Delaroche. *The Children of Edward* (detail). 1830. Louvre
Paul Cézanne. *Portrait of the Artist's Son* (detail). 1883–85. Louvre
(Musée de l'Orangerie. Collection Jean Walter and Paul Guillaume)
Jacques Sarrazin. *Bust of Louis XIV as an Infant.* c. 1643. Louvre

Cat *(counterclockwise from left):*

Egyptian. Mummified Cat. 11th c. B.C. Louvre
Pierre Bonnard. *The White Cat.* 1894. Orsay
Jean-Baptiste Siméon Chardin. *The Ray* (detail). 1728. Louvre
Edouard-Félicien Eugène Navellier. *Sleeping Cat (Cat Study No. 4).*
1925. Orsay

Dog *(counterclockwise from top left):*

French (Théatre de Budt à Lille). Winged Dog-Dragon (detail).
Late 19th c. ATP
Rembrandt Bugatti. *Basset Hound (Wurst, the Artist's Dog).*
20th c. Orsay
Eugène Boudin. *The Beach at Trouville* (detail). 1864. Orsay
(photograph: C. Jean)
Charles Le Brun. *The Hunt of Meleager and Atalanta* (detail). c. 1665.
Louvre

Bird *(counterclockwise from top left):*

Fernand Léger. *Composition with Two Parrots* (detail). 1935. AM
I. Adam. Weathervane (detail). 19th c. ATP
Henri Rousseau. *The Snake Charmer.* (detail). 1907. Orsay
Henri Matisse. *Oceania, the Sky.* 1946. AM
French. Medallion. c. 1870. AD
French (Paris). *Holy Spirit Pendant.* 18th c. ATP

Girl *(counterclockwise from top left):*

Paolo Veronese. *Supper at Emmaus* (detail). c. 1560–63. Louvre
Balthus. *The Painter and His Model* (detail). 1980. AM

French. Bisque Doll. Late 19th c. AD
French. Papier-mâché Doll. Early 20th c. AD
Diego Velázquez. *Portrait of the Infant Marguerite (Daughter of*
Phillipe IV, King of France). c. 1655. Louvre
Jean-Antoine Houdon. *Sabine Houdon at the Age of Ten Months.*
Late 18th or early 19th c. Louvre

Flower *(counterclockwise from left):*

French (Savoy). Belt (detail). 1900. ATP (photograph:
Daniel Haddad)
French. Tapestry. 1925. AD
Odilon Redon. *Bouquet of Wildflowers.* Early 20th c. Orsay
Claude Monet. *Monet's Garden at Giverny* (detail). 1900. Orsay
Girolomo Pini. *Flower Study* (detail). 1616. AD
Alfred Stevens. *The Bath* (detail). c. 1867. Orsay

Eyes *(counterclockwise from top left):*

Leonardo da Vinci. *Mona Lisa* (detail). 1503. Louvre
Théodule Ribot. *At the Sermon* (detail). c. 1890. Orsay
(photograph: C. Jean)
Pablo Picasso. *Woman in a Hat.* 1935. AM
Coptic. Fabric fragment, *Head of a Dancer.* 5th c. Louvre

Chair *(from left to right):*

Fantenie. Chair, "Directoire" style. Late 18th c. AD
Edgar Degas. *The Dance Foyer at the Opera on the Rue de la Peletier*
(detail). 1872. Orsay
Pieter de Hooch. *A Woman Drinking with Two Gentlemen.* (detail).
1658. Louvre
Vincent van Gogh. *Van Gogh's Room at Arles* (detail). 1889. Orsay
Jacques-Louis David. *The Readers Bringing to Brutus the Body of*
His Son (detail). Louvre

Tree *(counterclockwise from left):*

Oriental carpet, *The Garden.* 18th c. AD
Yves Klein. *Blue Sponge Tree.* 1962. AM
Jacob Isaacksz. van Ruisdael. *The Bush.* 17th c. Louvre
Desfossé and Karth. Wallpaper, *Panorama of Eden* (detail).
1860–61. AD